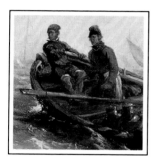

THE ART OF
SEASCAPES

Edmund Swinglehurst

A Compilation of Works from the
BRIDGEMAN ART LIBRARY

SIENA

Seascapes

This edition first published in 1995 by
Parragon Book Service Ltd
Units 13-17 Avonbridge Industrial Estate
Atlantic Road
Avonmouth
Bristol BS11 9QD

ISBN 0 75251 199 8

Printed in Italy

Editors: Barbara Horn, Alexa Stace, Alison Stace, Tucker Slingsby Ltd and
Jennifer Warner.
Designers: Robert Mathias and Helen Mathias
Picture Research: Kathy Lockley

The publishers would like to thank Joanna Hartley at the
Bridgeman Art Library for her invaluable help.

Seascapes

Seascapes as a genre of painting developed with the growth of seapower in Europe. Although there are glimpses of sea and ships in paintings by Carpaccio and Pieter Brueghel, they are not the main subjects of the painting, as they became later. It was the great powers' struggle to dominate the sea and its trade that brought the sea into the foreground of the public mind, especially that of anyone who had anything to do with the sea either as a merchant or seaman.

The most accomplished painters of the sea and coasts were the Dutch, perhaps because of the part that waterways had played in ridding them of the Spanish Imperial yoke. The small Dutch nation felt itself to be very much a sea power. One of the first Dutch painters of note was Cornelius Vroom, who was commissioned by England's Lord High Admiral to paint a picture of the Spanish Armada being attacked by the smaller, more manoeuvrable ships of the English fleet. Later in the 17th century, Charles II acknowledged the expertise of the Van de Veldes, father and son, by inviting them to England to become his official sea painters. A century later, George III employed Dominic Serres in a similar post.

Most early Dutch paintings were of ships in coastal waters either at rest or going about their business as freighter or fishing vessels. In the eighteenth century things changed. The wars at sea between French, Spanish,

Dutch and British fleets grew with their national rivalries, fanned to a high pitch by the discovery, settlement and exploitation of colonies in the Americas and beyond. A large part of the demand for sea pictures in the 18th century was as records of victories at sea, many of them commissioned by admirals or captains who had taken part in the battles, while others were requested for more sentimental reasons by officers wanting portraits of the ships in which they had served.

In Britain, scenes of sea battles became extremely popular, culminating in vast canvases of the greatest sea battle of all, Trafalgar, in 1805. The battle which confirmed Britain's mastery of the seas for most of the century was painted by Turner, Constable, Pocock, Stanfield Clarkson and others, none of whom had been there but whose ready imaginations were able to serve the public demand just as newspapers and television do for the wars of today.

Once Napoleon had been defeated, painters began to take a more romantic view of the sea. Poets like Byron, Keats and, especially, Coleridge saw the sea as a mysterious element of nature full of both beauty and danger - it was another universe. For Turner, with his philosophic turn of mind, the sea became another realm indeed, into which he projected his pessimistic views about the universe, depicting storms and shipwrecks with desperate human beings hanging on for dear life to spars and rigging.

Other painters, like David Cox and Richard Bonington, did not have such a gloomy view and produced some beautiful watercolours of the seas in romantic aspects. There was still, well into the 20th century, a market in Britain for paintings celebrating the conquest of the seas; sea battles continued to be painted in considerable num-

bers and, indeed, still are today by numerous societies of painters dedicated to depicting this historic view of the sea.

Most painters, however, began to explore the idea of the sea in a human context, with the seashore becoming as important a subject as the sea and the ships on it. Whistler saw the sea in this way and so did Monet who, having spent his childhood in Le Havre, had a special feeling for sea and coasts.

After Monet had painted the sea in many moods, it became a standard subject for painters who lived near it or had a special feeling about it. Among these were Wilson Steer, Seurat, Signac, Winslow Homer and others. The choice of the sea as a subject tended to be determined by its familiarity to the painter, so that after Cézanne opened the way to a more structured approach to landscape, most painters turned to the countryside for inspiration.

Like the public in general, many painters enjoy holidays by the sea and thus seascapes have continued to be painted. There have been many attractive and atmospheric paintings produced of resorts like Nice, St Tropez and Collioure in the south of France and of the fashionable resorts of the north like Trouville, Deauville and Honfleur. On the whole, however, the sea as a subject to which a painter can devote most of his work has gradually been losing its attraction in an age when art is a matter of ideas and abstractions.

▷ **The Fall of Icarus** 1555
Pieter Brueghel the Elder (c.1525/30-1569)

Oil on canvas

PIETER BRUEGHEL, father of Jan Brueghel and Pieter Brueghel II, was a famous painter of landscapes and genre scenes, often with a satirical twist. He visited France and Italy and returned to his native Netherlands more impressd by the scenery of Italy and the Alps than by the art he saw there. The effect of this is evident in this painting of the Greek myth of Icarus, where the view of the blue sea with its distant coastline and splendid towns is typically Italian. Later, Brueghel devoted himself to scenes of village life in which the Spanish authorities governing the Netherlands at the time may have read a satirical comment. This could have been the reason for Brueghel's move to Brussels in 1563.

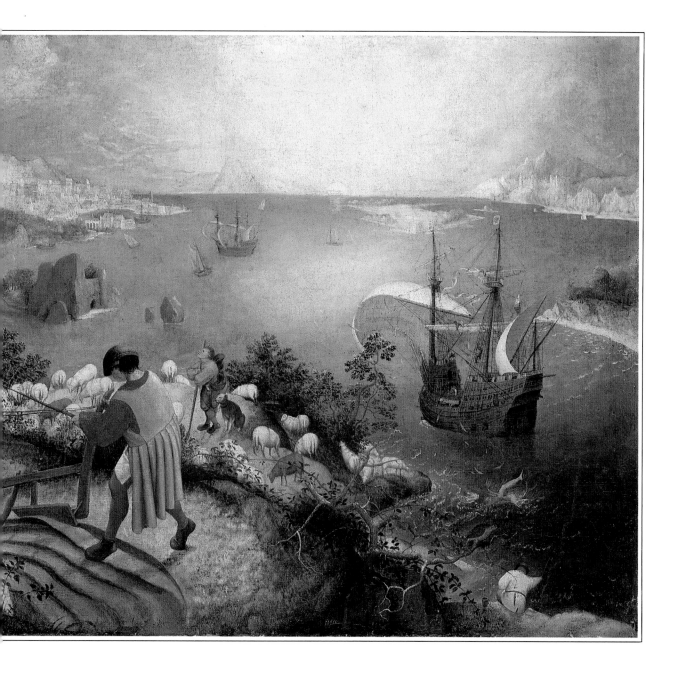

▷ The Spanish Armada
Hendryck Cornelius Vroom (1566-1640)

Oil

VROOM WAS BORN in Haarlem, a sea port in Holland, and became one of the founders of the Dutch school of marine painting. Like most marine painters of his day, he went to sea at an early age and thus obtained firsthand knowledge of the ways of the sea, of the movements of wind and wave and their effect on ships. Once he was shipwrecked off the coast of Portugal, where the local inhabitants, thinking that he was an English pirate, were ready to despatch him, but then discovered his talent for drawing. As an artist and not an Englishman he was given hospitality until he could return home. Vroom worked for English patrons, among them Lord Howard of Effingham, Earl of Nottingham, who was Admiral of the Fleet at the time of the Spanish Armada. For Nottingham, Vroom painted cartoons for tapestries depicting the Armada which hung in the Houses of Parliament until they were burned in the great fire of 1834.

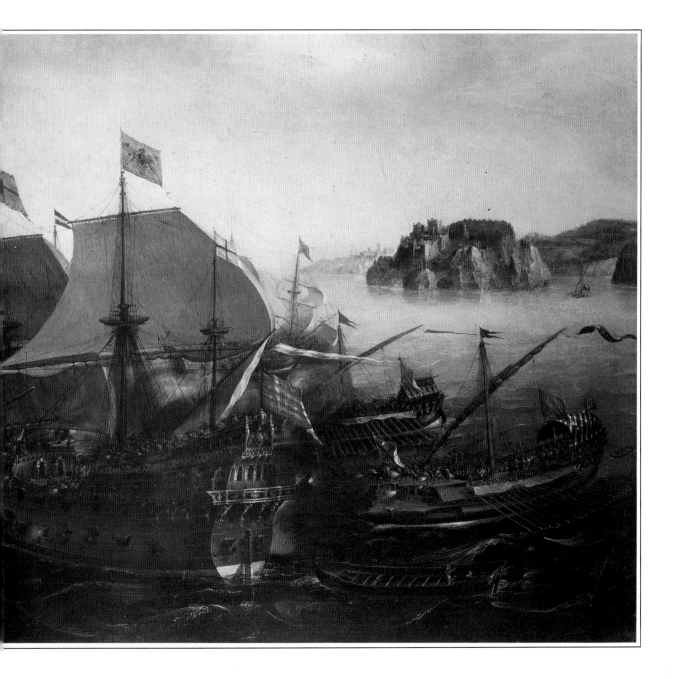

▷ **Shipping Scene**
Simon Jacobsz Vlieger (1600-53)

Oil on canvas

THE STRUGGLES of the Dutch to
break free from the Spanish
Empire came to a successful
conclusion thanks in part to
the Dutch people's expert
knowledge of the sea and
waterways. The coastal waters
became areas of particular
national importance and
inspired many Dutch painters.
Vlieger became a pupil of Van
de Velde the Elder, who had
himself been a pupil of
Vroom, and passed on his
technique to Van de Velde the
Younger. Thus the sea
painting tradition, with some
Italian influence, was passed
on. In this painting of coastal
shipping Vlieger's fine sense of
light, based on the use of
subtle tones of grey, is clearly
evident. The accuracy of his
observation set a standard
which helped make Dutch sea
paintings the best of their day.

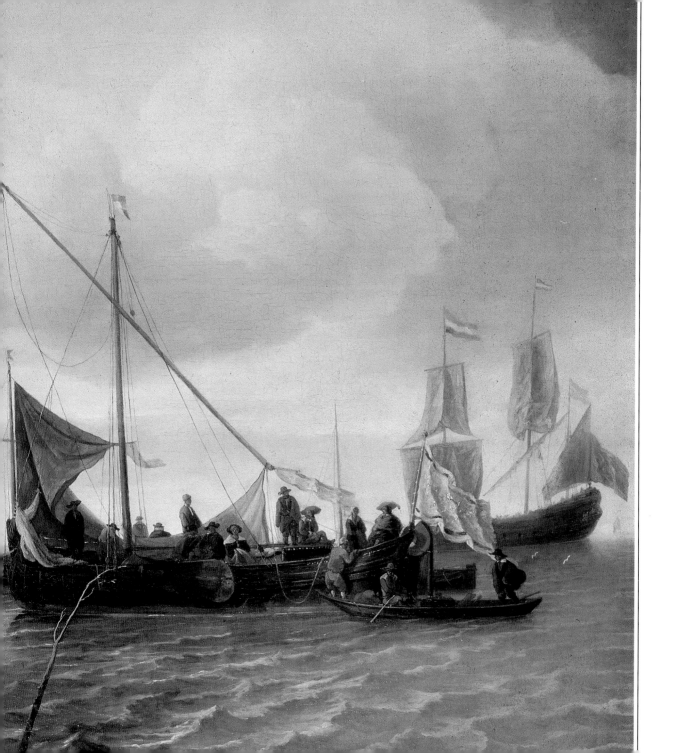

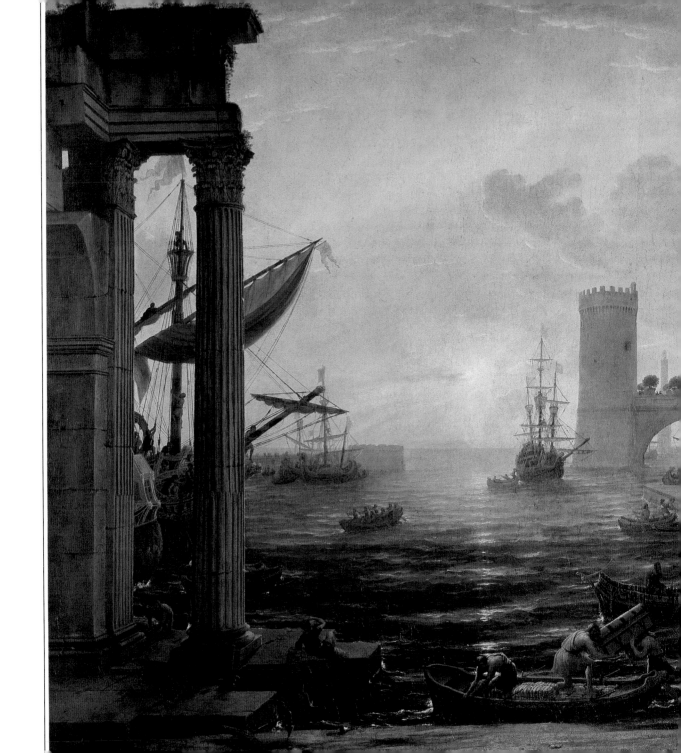

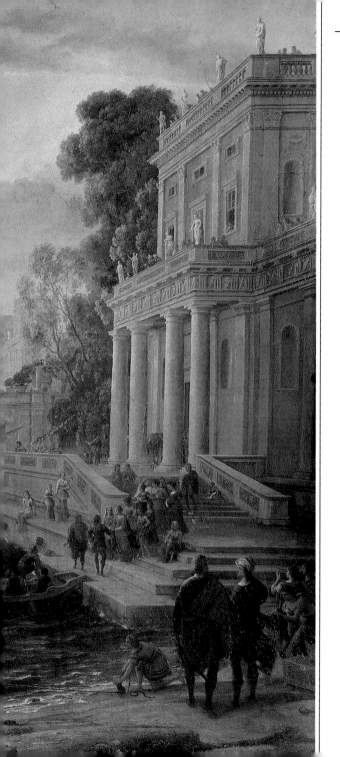

◁ **Embarkation of the Queen of Sheba** 1648
Claude Lorraine (1600-82)

Oil on canvas

CLAUDE LORRAINE, who was born in Lorraine into a family with the name Gellée, trained as a pastry cook but deserted this career for painting. He went to Italy in his early teens, where he absorbed much of the great Italian painters' classical culture and painting techniques. By the late 1630s he was well known for his glowing paintings of landscapes and seascapes with mythological and classical settings. Having established his style, with its mannerist influences in part derived from his early master, the landscape painter Tassi, he rarely varied it. His compositions, of which this superb scene in the life of the Queen of Sheba is a fine example, were like stage settings with fore and middle foreground wings and a distant horizon with hills and a rising or setting sun. The variety in his paintings came from his delicate sensibility for light values, which illuminate his canvases, giving them an inexhaustible interest.

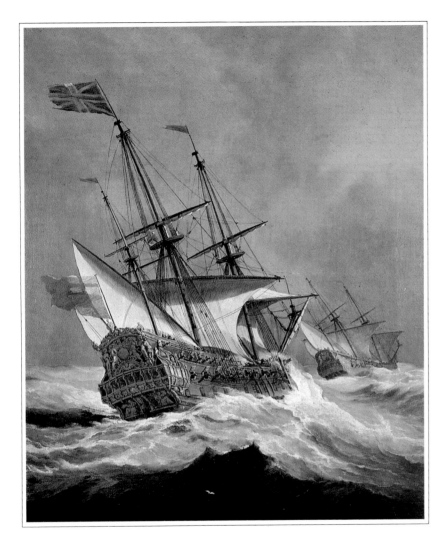

◁ ***Resolution* in a Gale**
Willem Van de Velde the
Younger (1633-1707)

Oil on canvas

VAN DE VELDE the Younger
was a better painter than his
father, who was a master of
accurate drawing and grisailles
(decorative monochromes).
Father and son seem to have
worked together, with Van de
Velde the Younger adding
colour to his father's drawings.
Their skill as marine painters
caught the attention of Charles
II, who invited them to
London in 1672, paying each
of them £100 as his official
marine artists. Van de Velde
the Elder was the first painter
to accompany a royal fleet into
battle, with the Dutch admiral
Van Tromp, and both father
and son captured some of
their finest effects while
drawing sea-fights from a
small boat in the thick of the
action. Van de Velde the
Younger painted more than
600 marine pictures, most of
them of very high quality,
making him the finest painter
of the Dutch marine painting
tradition and the father of
English marine painting.

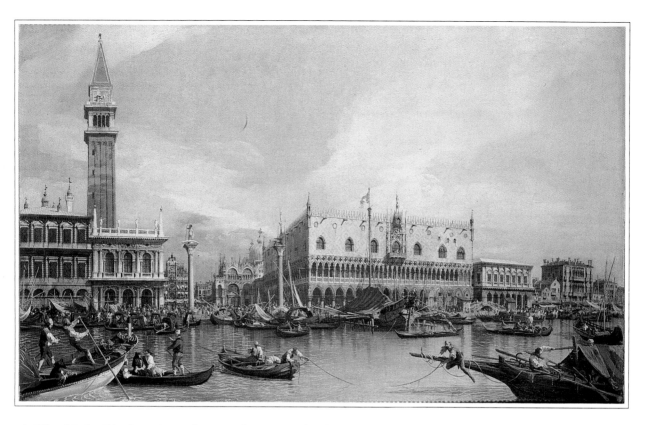

△ **The Molo, Venice** Antonio Canaletto (1697-1768)

Oil on canvas

THE VENETIAN-BORN Canaletto was a painter of views for rich tourists, particularly English ones on the Grand Tour, and developed a style which was clear, crisp and easily accessible, even to art collectors who did not know much about aesthetics. At first he painted from nature, from the shore or from a gondola in the Venetian lagoon; later, he worked in his studio from drawings and notes, some of which were done with the help of a camera obscura. He had many English admirers who saw in the history of Venice a reflection of that of their own country, though in a more exotic setting. It was probably the English consul in Venice, Joseph Smith, who arranged Canaletto's long visit to England in the 1740s. In this picture, with its typically marked contrasts of light and shade, Canaletto has shown not only the magnificent buildings of the Venetian waterfront but also the daily life of a busy commercial port with vessels unloading their goods and small boats carying them to other islands.

▷ **Barrington's Action at St Lucia** 1779
Dominic Serres (1722-93)

Oil on canvas

FOR MORE THAN two centuries, the Caribbean was a battleground for the fleets of the British, French and Dutch as they vied for colonial possessions, for mastery of the trade in sugar, spices and the rich spoils of Spanish galleons returning from South America. By the 18th century, it had also become a fine subject for the work of marine painters. British admirals, such as the distinguished Admiral Samuel Barrington, whose successful engagment off St Lucia in December 1778 is recorded in this painting, liked to have paintings as records of the high points of their careers as well as portraits of their flagships. Both battles and ships' portraits were specialities of Dominic Serres. His accuracy in depicting a naval action was much admired, one admiral commenting that 'the subjects are so well described that we even fancy ourselves anchored on the spot'.

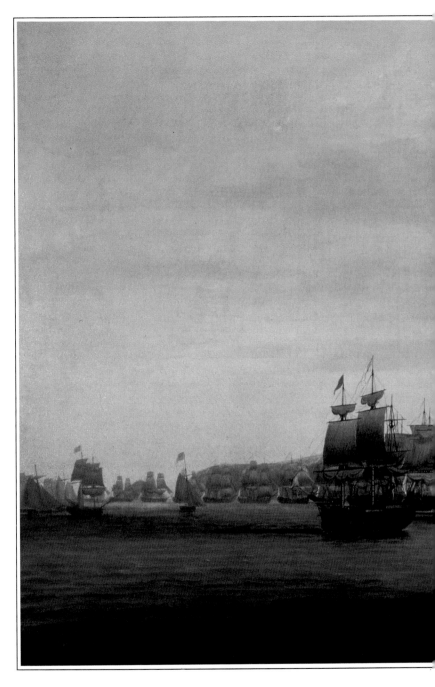

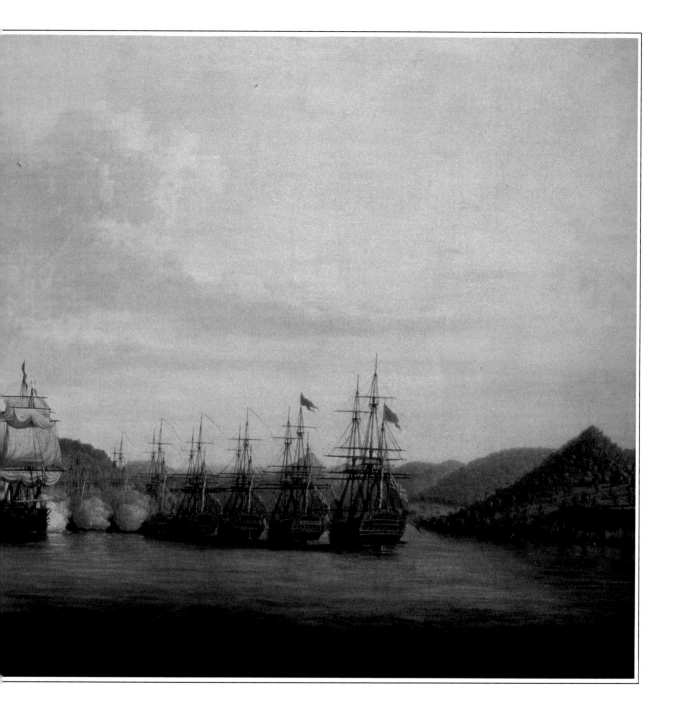

▷ Post Office packet *Lady Hobart* Wrecked on an Iceberg
Nicholas Pocock (1741-1821)

Oil on canvas

BRISTOL-BORN Nicholas Pocock was a sea captain before he became a painter, decorating his log book at sea with excellent drawings. He was encouraged by Sir Joshua Reynolds to take up painting as a career. Pocock soon became popular with British collectors of sea paintings for his ability accurately to depict actions at sea. He was very confident of his skill and reckoned that three colours were enough to produce the effect of any colour. In this depiction of a real incident at sea, he has painted the wreck of the Lady Hobart from imagination but based on information he managed to glean about the disaster.

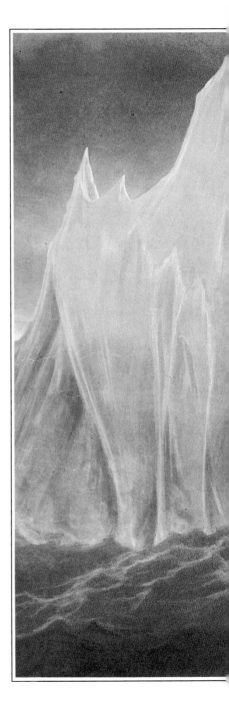

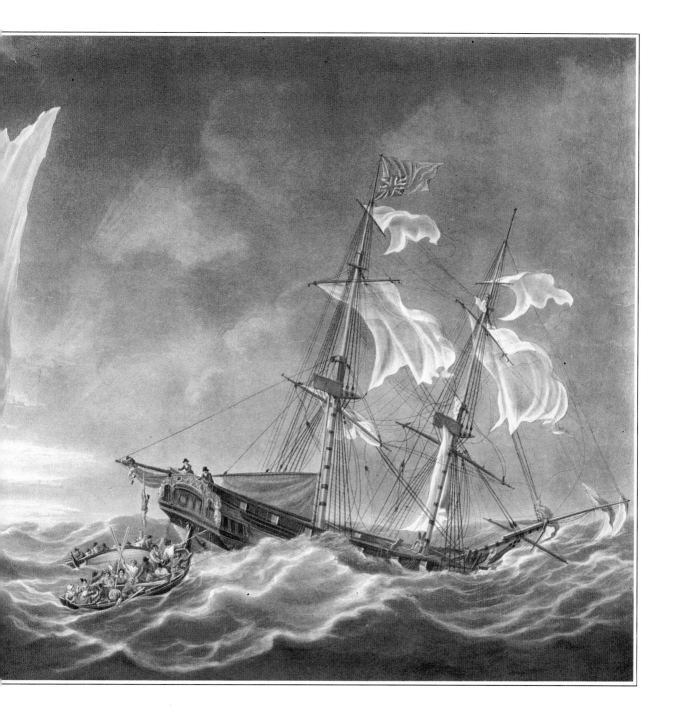

▷ **Comte de Grasses's Action at Frigate Bay, St Kitts, 26 January 1782**
Thomas Whitcombe
(1760-1824)

Oil on canvas

WHITCOMBE'S GRAND panoramic action picture of the opposing fleets of the Comte de Grasse and Admiral Hood made a great spectacle for the public when it was shown at a Royal Academy exhibition in London for it brought the battle, which had taken place thousands of miles away in the Caribbean Sea, close to them. Whitcombe later made a name for himself as a painter of scenes from the French Revolutionary wars and made fifty plates to illustrate a book, *Naval Achievements of Great Britain*. He exhibited at the Royal Academy from 1783 to 1824 and in his time was considered the equal of Nicholas Pocock as a painter of sea subjects.

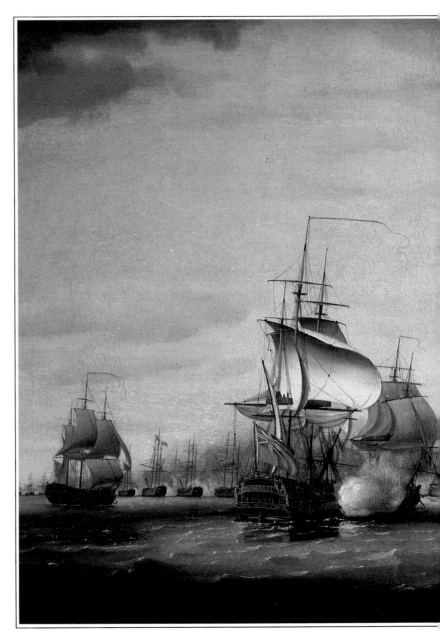

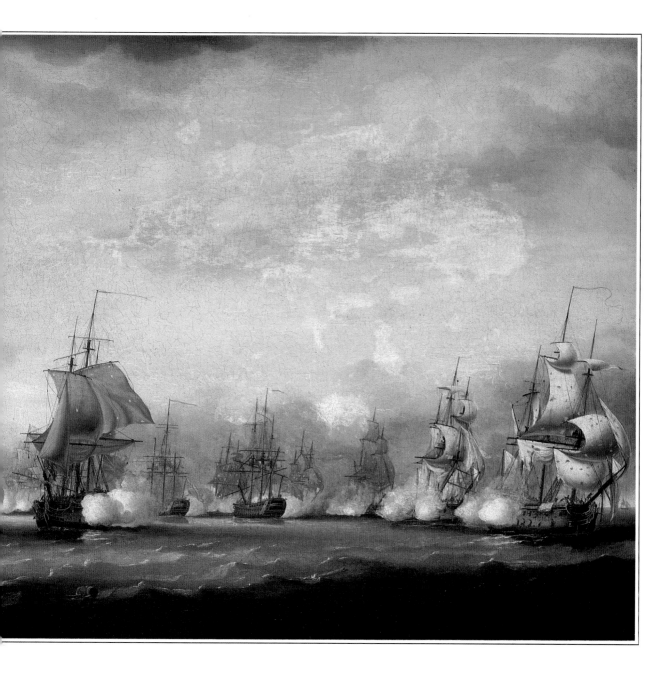

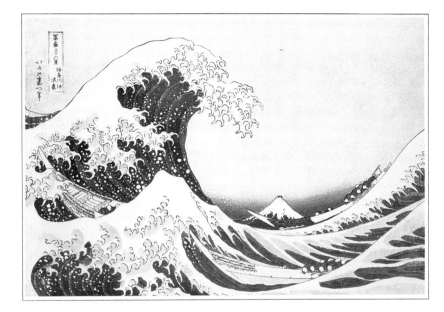

△ **The Great Wave of Kanagawa** c.1831
Katsushika Hokusai (1760-1849)

Woodblock print

WHILE EUROPEAN PAINTERS were edging away from conventional techniques of Western paintings and moving towards realism, Hokusai was using age-old Japanese painting methods and creating something new by his inner vision. In this famous woodblock print, from the series *36 Views of Mt Fuji*, published in 1831, Hokusai treats the subject in the simplest possible way, but with a great sensitivity for the large forms and sweeping lines of the drawing. It was an approach copied by the Impressionists later in the century. In Hokusai's *Wave* the boats which express the human dimension of the scene are barely discernible and Mt.Fuji, featured in the title of the series, is a distant, though dominating shape in the background.

▷ **Moon Setting by the Sea**
Caspar David Friedrich
(1774-1840)

Oil on canvas

TO THE AVERAGE 19th century European, the seas seemed more peaceful than they had to earlier generations: there were fewer war-like fleets roaming the oceans and the habit of going to the seaside on holiday was growing. A new, more peaceful and romantic atmosphere came to surround the work of the marine artist. Caspar David Friedrich, a visionary and imaginative German romantic painter, created his own versions of landscapes and seascapes. Starting with scenes he had witnessed, he gave them a unique dreamlike quality which distinguished them from the work of his contemporaries. Here, the three figures silhouetted against the setting moon look out towards ships that evoke ideas of romantic voyages, perhaps in the surreal world of the unconscious.

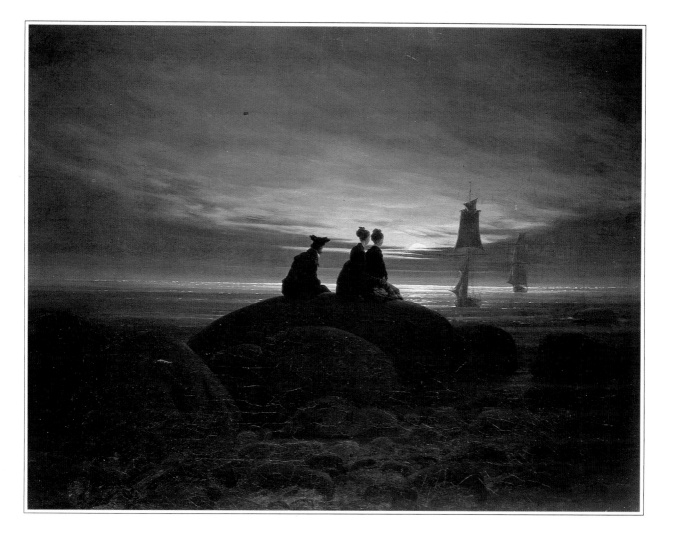

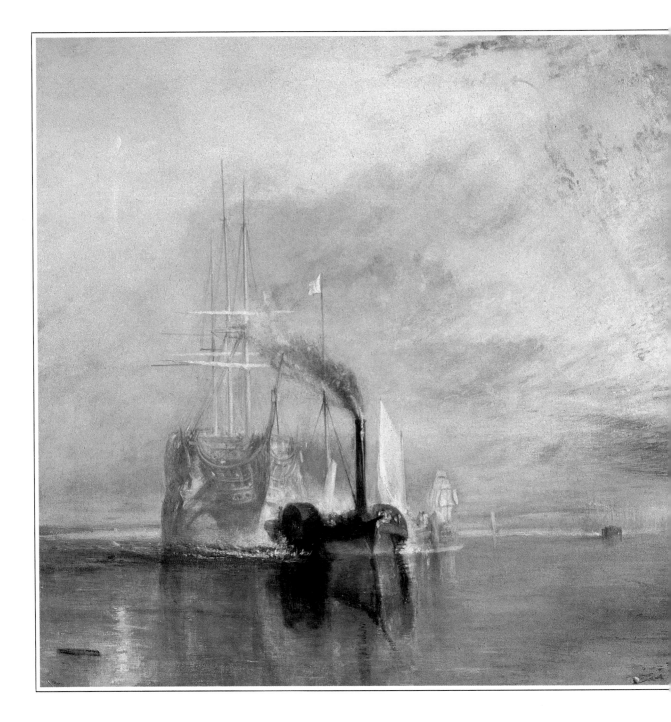

◁ **The Fighting *Téméraire* Tugged to her Last Berth to be Broken Up, 1838** 1838/9
Joseph Mallord William Turner (1775-1851)

Oil on canvas

THAT TURNER WAS interested in the sea from an early age is attested to by the fact that one of his earliest works in oil was a painting of Calais Pier showing a stormy sea with French and English fishing smacks, the latter showing better seamanship than the former. Although not a man for great patriotic gestures in paint, Turner shared the average Englishman's pride in the Royal Navy. He imbues this magnificent painting with a note of ghostly nostalgia, showing the great fighting ship from the days of sail - she fought at Trafalgar - being towed to the breakers' yard by a steam tug; a new moon has risen in the sky at the moment of sunset. Turner was never concerned with the exactitude of his pictures of ships and their rigging, a fact which once led the royal sailor, the Duke of Clarence, later William IV, to say to him, 'Sir, you don't know who you are talking to and I'll be damned if you know what you are talking about.'

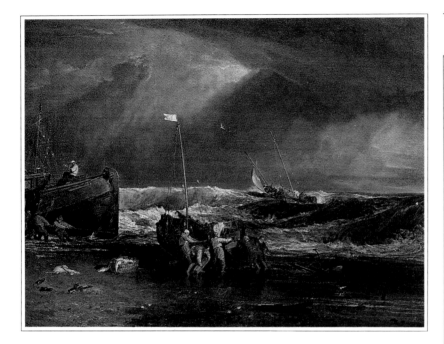

△ **Fishermen Upon a Lee Shore** 1803/4
Joseph Mallord William Turner

Oil on canvas

IN THIS STORMY SEASCAPE, very typical of Turner's style, the artist introduces a new vision of man's relationship with the sea. The watery realm is not simply a battlefield but a setting from which man struggles to obtain its natural wealth just as a farmer does when working the land. Unlike his earlier work, in which landscapes were settings for classical subjects, Turner's later work came to depict the earth as an environment in which feeble man struggled for survival. This became more and more the theme of Turner's visions of the sea; the sure touch, very evident in the handling of sky and waves in this painting, became freer and more atmospheric as he himself struggled to express his feelings.

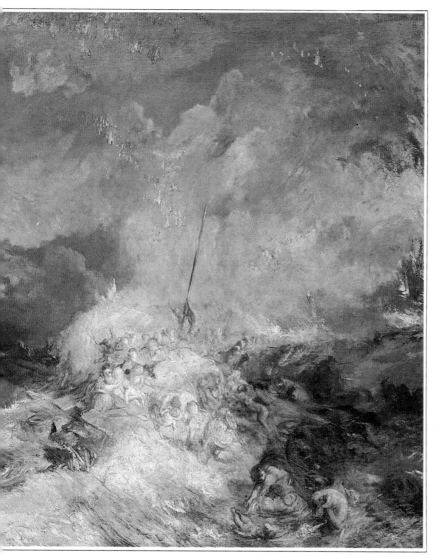

◁ **Fire at Sea** 1835
Joseph Mallord William
Turner

Oil on canvas

THE FLUIDITY and formlessness
of the sea allowed Turner to
make of it what he wanted.
With his skilled touch he could
stir it up into a mysterious
realm where the force of life
was expressed with great
passion. Basically, Turner was
a pessimist but not one to
allow himself to be defeated:
his sea paintings might show
puny humans being
overwhelmed by the power of
nature but they are not
vanquished. In this painting,
the fire which has caused the
disaster is hardly visible,
except as flecks of light on the
clouds, but its effects are
horrifyingly clear in a scene
painted with all Turner's
unrivalled delicacy and
strength of brushwork.

◁ **Brighton Beach with Colliers** 1824
John Constable 1776-1837

Oil on paper

THOUGH CONSTABLE'S favourite painting territory was the countryside around Dedham Vale in Suffolk he also painted many other landscapes. The sea entered his list of subjects when his wife fell ill and he took her to Brighton, persuaded like many others at the time that sea air and salt water baths were good for the health. At first, Constable was not especially impressed by the flat emptiness of the sea but the cloud effects in the skies, of which he had already made many studies in Suffolk and Hampstead, began to interest him, as did the seeming infinity of space, as depicted in this view along the Brighton shore. It was one of a series of oil sketches Constable made in Brighton in the summer of 1824, most of them 'done in the lid of my box on my knees', as Constable told a friend.

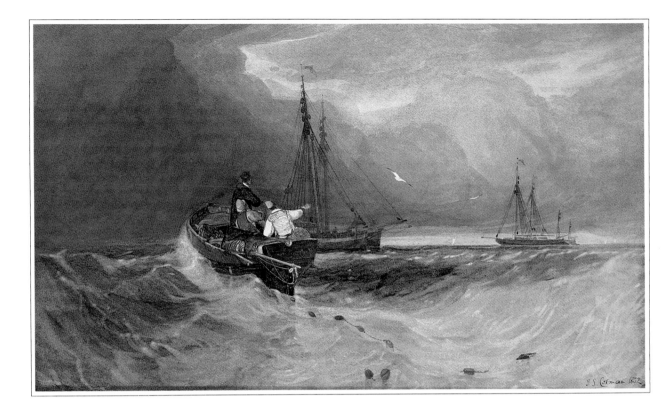

△ **Fishing Boats off Yarmouth** John Sell Cotman (1782-1842)

Watercolour

AFTER THE DEFEAT of Napoleon, British public feeling about the sea underwent a change, and artists' depiction of the sea underwent a change too. There was no longer any need to feel patriotic about the feats of the Royal Navy, while a view of nature as a picturesque and largely benevolent gift from the Creator for man's enjoyment and enlightenment was encouraged by the Romantic movement. John Sell Cotman, one of England's greatest watercolourists, was born in Norwich and, though he worked a great deal in London, became a leading painter of the Norwich School, which was memorable for the quality of its landscapes. In this picture of fishermen laying their nets, Cotman has made the sea appear rough but not malevolent. Later in his life, Cotman took to thickening his watercolour with rice paste, which gave his work an impasto effect (heavy laying on of colour) useful for his architectural studies but not for the transparent effects of wind and water.

▽ **Scarborough** David Cox (1783-1859)

Watercolour

ENGLISH-BORN David Cox was principally a landscape watercolourist who later in his long career used a rough, cheap type of wrapping paper to achieve a vigorous quality in his painting. Like Constable, he was a topographical artist, recording as accurately as he could the scene before him and avoiding using it as a vehicle for philosophical opinions. In this sense, he was a forerunner of the majority of 19th century English landscape painters. Scarborough was the first English seaside spa, possessing both sea water and mineral springs, so that it was much recommended by doctors for people who suffered, or thought they suffered, from a variety of ailments. Anne Brontë, for example, was genuinely ill when she visited Scarborough with her sisters. Because it had so many middle-class visitors, the town was a popular subject for artists hoping to sell watercolours and prints.

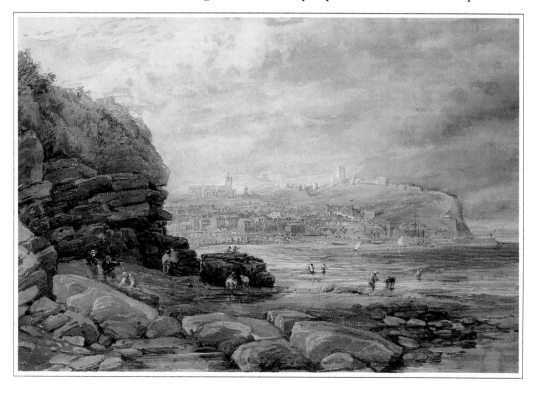

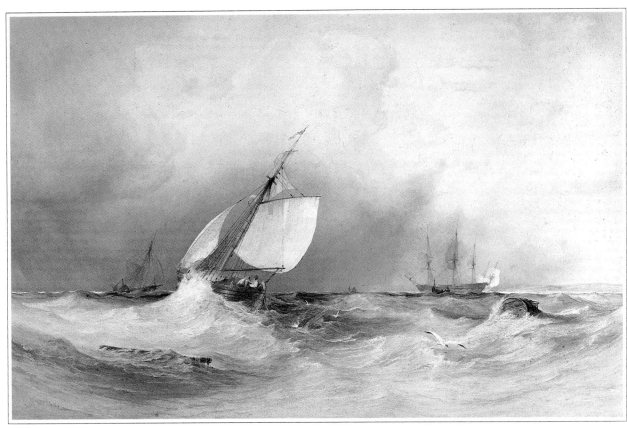

△ **Seascape off the South Coast** 1829
Anthony Vandyke Copley Fielding (1787-1855)

Watercolour

HIS NAMES SUGGESTING that his parents had high hopes for him even in the cradle, Fielding did, in fact, become one of England's leading watercolourists. His teachers were his father, who was skilled in painting dramatic cloud effects, and the watercolourist John Varley. He began exhibiting with the Watercolour Society in London in 1810 and became its president in 1831, three years after this atmospheric picture was painted. He lived at Sandgate and Worthing on the south coast, which provided the subjects for many fine watercolours, for some years at the end of his life. He never went abroad but was highly admired by Ruskin.

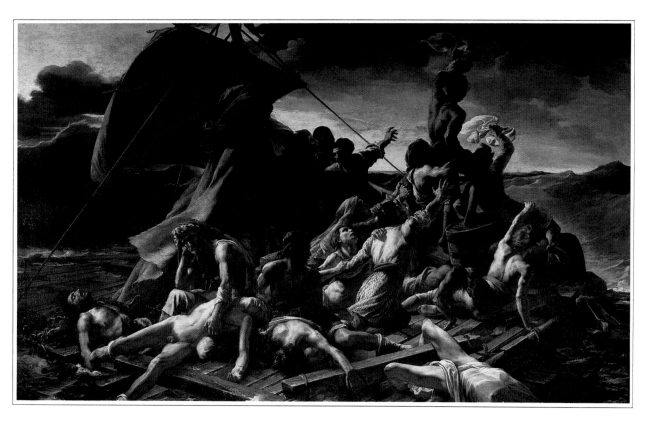

△ **The Raft of the** *Medusa* 1819 Théodore Géricault (1791-1824)

Oil on canvas

GÉRICAULT'S FAMOUS sea picture has some of the elements of a Turner painting, especially in its portrayal of man's desperate stuggle with nature. In Géricault's case the shipwreck which was one of the great political scandals of the day in France, had political implications. Géricault was using it to express his sympathy with the liberal opponents of the reactionary monarchy of Louis XVIII, restored after the defeat of Napoleon. The success of this dramatic work meant that it was exhibited in various other European cities, including London and other English cities. Géricault visited England while his painting was being exhibited there and made many drawings of the poor and underprivileged classes of the Industrial Revolution.

▷ **The Shipwreck**
Francis Danby (1793-1861)

Oil on canvas

IN THIS DRAMATIC PICTURE the Irish painter Francis Danby, best known for the large historical and biblical pictures which dominated his later output, has pulled out all the stops to satisfy the 19th century public demand for pictures of drama at sea which was comparable to today's interest in disaster photos and film. Danby travelled extensively in Europe and was much influenced by the French painter Claude Lorraine who painted seascapes with a classical setting. Danby exhibited at the Royal Academy from 1821 to 1860 and was disappointed not to be made a full Academician.

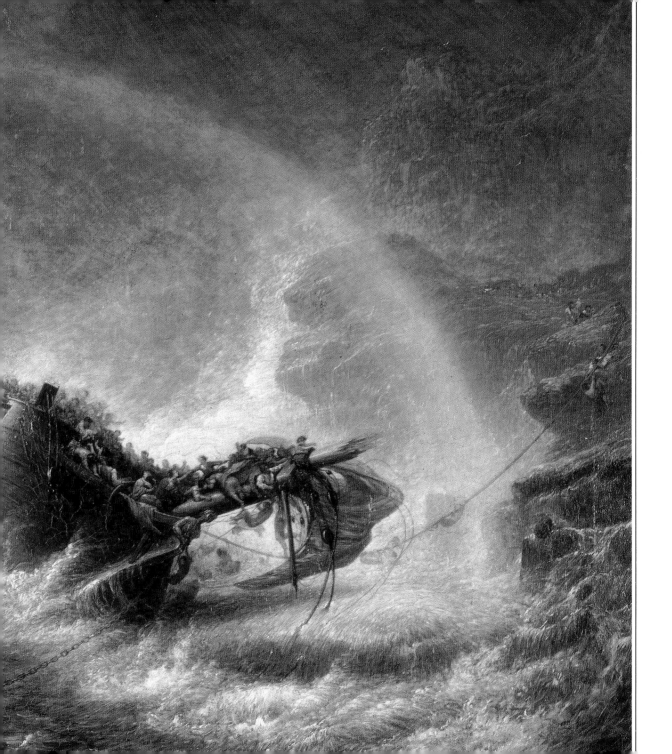

▷ **Battle of Trafalgar** 1836
William Clarkson Stanfield (1793-1867)

Oil on canvas

CLARKSON STANFIELD, born in Sunderland of Irish parents, began his working life in the navy and ended it a Royal Academician. Like many painters of his time, including Turner and Constable, Stanfield responded to the public demand for pictures of the great sea battle in which the nation's hero was killed, with a powerfully theatrical painting. Stanfield's painting, though done from imagination, has the authority of an artist who knew about ships and their rigging; it shows the British ships, flying the Union Jack, breaking through the French line. Stanfield's sense of panoramic composition came from his years as a scene painter in the East London and Coburg (Old Vic) theatres, where he first came to public attention. In this painting he has done more than justice to the great ships, though the sea lacks the liveliness and strong feeling of reality which an artist like Turner would have imparted to it.

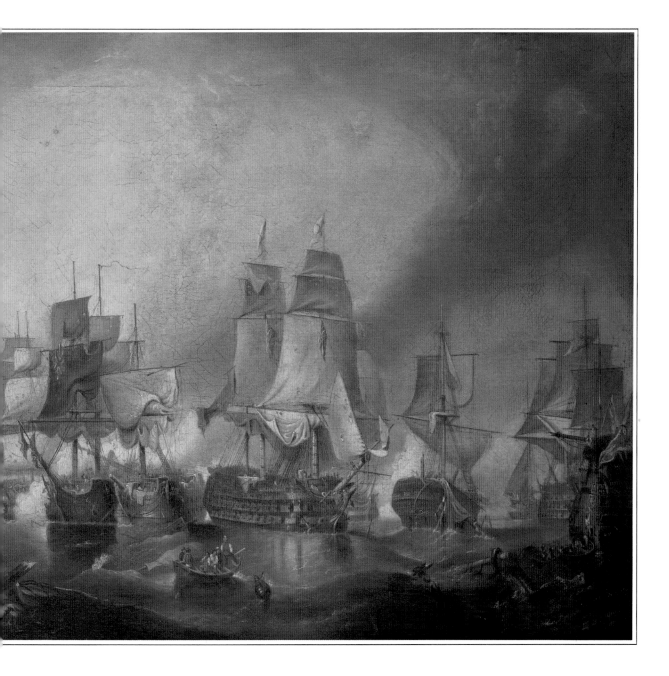

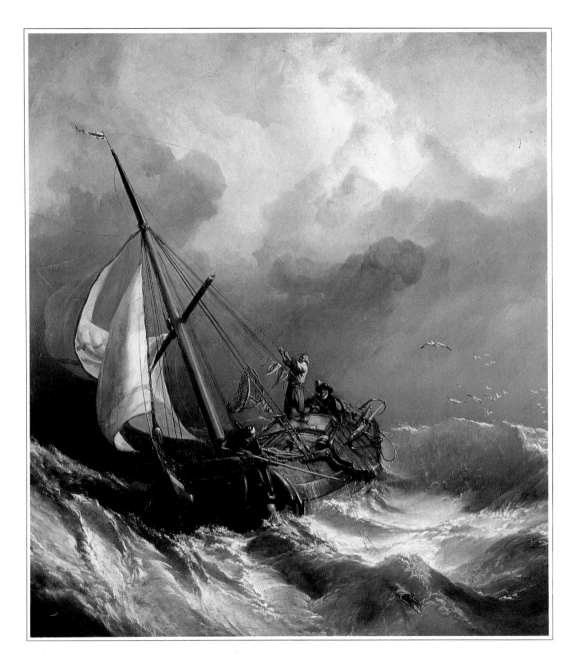

◁ **On the Dogger Bank** 1846
William Clarkson Stanfield

Oil on canvas

THE DRAMA OF THE SEA, especially in relation to the hard life of fishermen, continued to be a popular subject among Victorian art buyers and Stanfield was one of the main artists who supplied this demand. Turner's influence can be seen in the treatment of the waves and sky in this hazardous moment on the shallow seas of the Dogger Bank. Stanfield's interest in the sea was aroused in the first instance by Captain Marryat, author of *Midshipman Easy,* and this led him to a life at sea during which he made a long voyage to China. It was after missing a ship that Stanfield took up a shore job decorating ships and it was this which led him to make a serious study of painting.

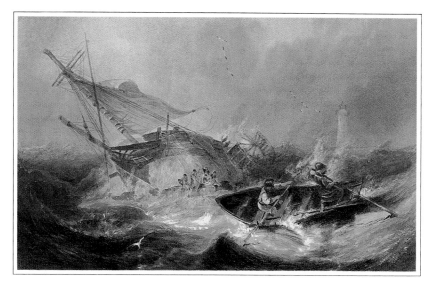

△ **Rowing to Rescue Shipwrecked Sailors off the Northumberland Coast**
James Wilson Carmichael (1800-68)

Watercolour

THE DRAMA OF THE SEA continued to be a popular theme during the rise of the newly affluent art-collecting middle classes of the Industrial Revolution. The importance of the sea to Britain's overseas trade and the dangers to which seamen were exposed became engrained in the national conscience. Carmichael was a painter who made the sea's many moods his subject. In this painting he shows a paddle steamer, which like most steam-driven ships still carried sail, shipwrecked off a North Sea coast lighthouse. The skirted figure in the rowing boat in the foreground suggests a reference to the heroic Grace Darling, who went out one stormy night in 1838 with her father, keeper of the Longstone lighthouse on Farne Island, to rescue nine men off a stricken steamer.

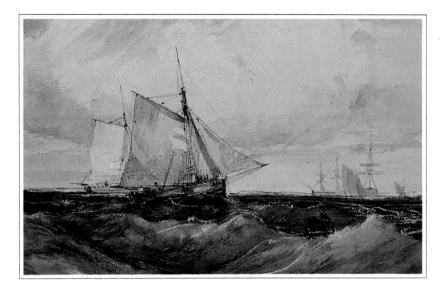

△ A Cutter and Other Ships in a Strong Breeze
Richard Parkes Bonington (1802-28)

Watercolour

RICHARD PARKES BONINGTON, English-born but artistically trained in France, was among the most talented painters of the early 19th century but died too soon for his genius to have its full flowering. He was a pupil of Delacroix, who once commented that the young Bonington was carried away by his own skill, and he also studied with Gros, a celebrated painter of the Napoleonic entourage and a pupil of David. Much of Bonington's time abroad was spent in France and in Italy, where he was influenced by the technique of the Venetian painters. By the time he returned to England in his mid-twenties, he was firmly in command of his own style. As this painting shows, he possessed a delicacy and strength of touch which rivalled that of Turner.

▷ HM Frigates at Anchor
John Joy (1806-57) and William Joy (1803-57)

Oil on canvas

THE JOY BROTHERS were born in Yarmouth on England's North Sea coast. It was not surprising, then, that from early on they had a strong feeling for the sea, which they expressed by drawing the dockside scenes in their home town. Later, they taught themselves to paint by copying the work of other, more famous marine painters. Together, they moved to Portsmouth, England's major naval port, set up a studio, and continued to paint the many scenes and ships in the naval dockyards. Their growing fame took them to London where they found plenty of customers by exhibiting, John at the Suffolk Galleries and William at the Royal Academy.

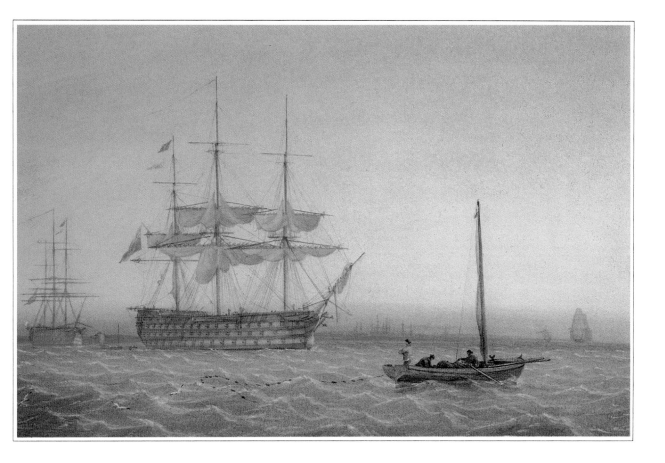

▷ **St Michael's Mount**
George Chambers the Elder
(1803 -40)

Oil on canvas

GEORGE CHAMBERS went to sea
at the age of ten, when he was
so small that he slept in his
uncle's sea boots. The sea
would have been his career but
for his talent for drawing
which enabled him to be
released from his indentures
to take up land-based work in
Whitby decorating ships. Easel
work came to him when he
was commissioned by a Mr
Crawford, owner of the
Waterman's Arms at Wapping,
London, to paint a marine
picture for the public house.
Chambers now developed his
talent for painting sea scenes
and was noticed by London art
collectors and, in particular, by
a member of the court of
William IV who brought him
to the atttention of the 'Sailor
King'. Among various
paintings by Chambers bought
by the king was one depicting
the opening of London
Bridge.

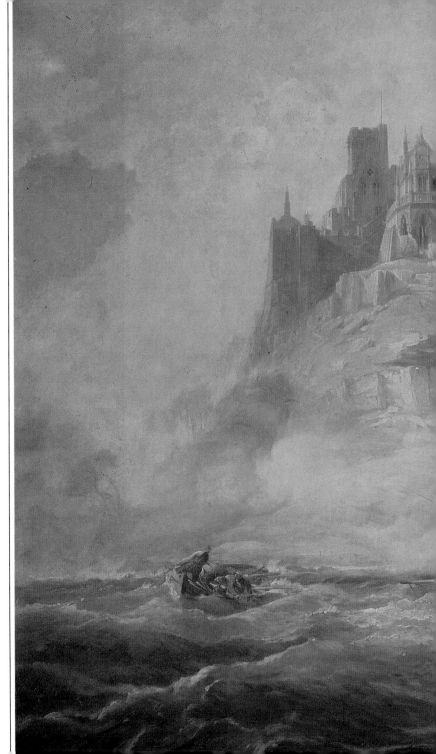

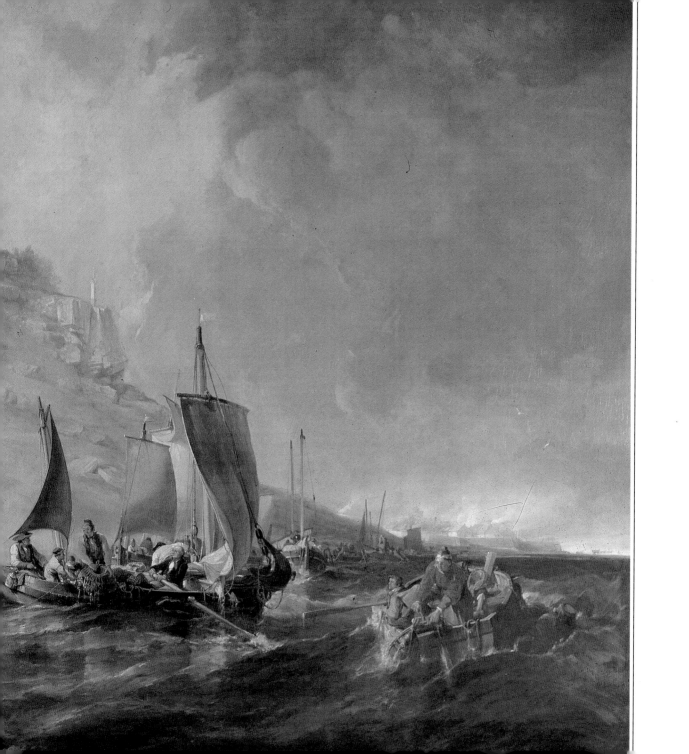

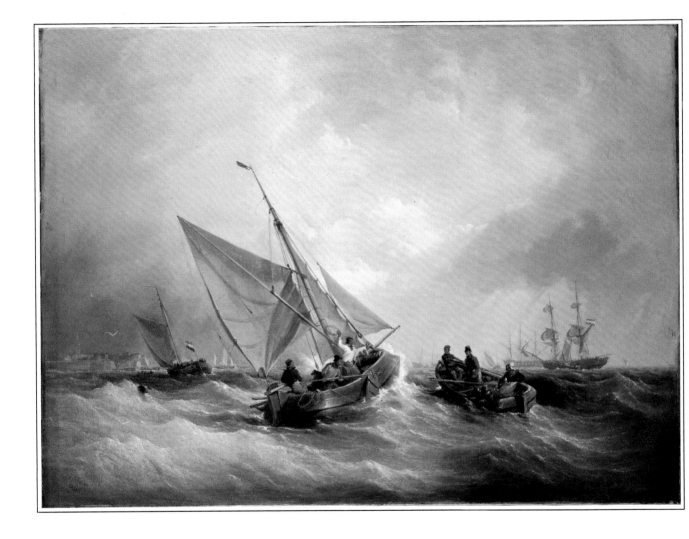

◁ **Shipping Scene**
Thomas Sewell Robins

Oil on canvas

ROBIN STUDIED at the Royal
Academy Schools under
Professor Thomas Phillips and
Turner who was professor of
drawing and perspective. It
could well be that Turner was
the inspiration for Robins
interest in paintings of the sea.
He was particularly talented in
the art of water colour and his
handling of sea and waves was
superbly confident. In 1839 he
was made an Associate of the
Water Colour Society. Like
most artists of his time he
travelled widely in Europe
visiting the Mediterranen and
France, also Holland where, by
the profusion of Dutch flags,
this picture was probably
painted. Robins was a
successful exhibitor at the
Royal Academy from 1629-
1874.

△ **Backways near Tintagel**
Samuel Palmer (1805-81)

Watercolour

SAMUEL PALMER was born in
London and in his
watercolour painting was
much influenced by his friend
Wiliam Blake, the visionary
painter and poet. Palmer
developed his own brand of
fantasy, especially during the
time he lived in Shoreham on
the south coast of England. In
this painting he takes a more
realistic view of the sea as he
paints one of the small rocky
coves near King Arthur's
castle at Tintagel in Cornwall.
The legends of King Arthur
and his knights, with their
mixture of Christian religion
and magic, would have
appealed to Palmer, though
none of this appears in this
painting which is, nevertheless,
more than a conventional
beach scene.

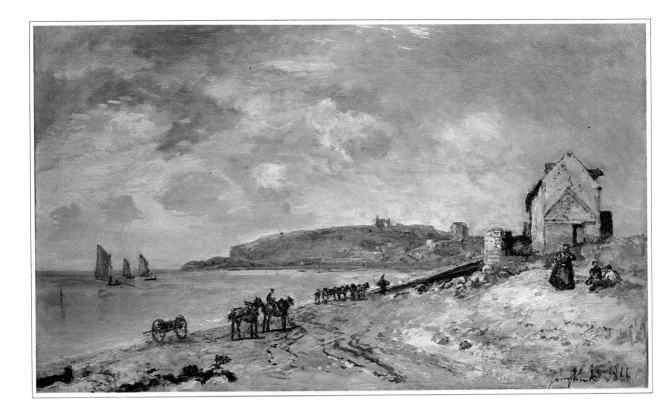

△ **Landscape with Ponies on the Beach** 1866
Johan-Barthold Jongkind (1819-91)

Oil on canvas

JONGKIND, THOUGH HE would not have considered himself an avant garde pioneer in art, was a forerunner of the Impressionists, dropping into Monet's mind the idea of painting en plein air and face to face with the subject. He was a friend of Boudin and Monet and all three often went out along the coast of northern France between Le Havre and Honfleur to paint. He usually worked in pencil or watercolour, turning his sketches into oil paintings in his studio. As one can see in this painting, his style was already in the 1860s approaching an Impressionist way of painting. Unsuccessful in his lifetime, Jongkind retired to Grenoble to paint and later had a mental breakdown from which he never recovered.

▷ **Large Sailing Boats at Honfleur** 1865
Johan-Barthold Jongkind

Oil on canvas

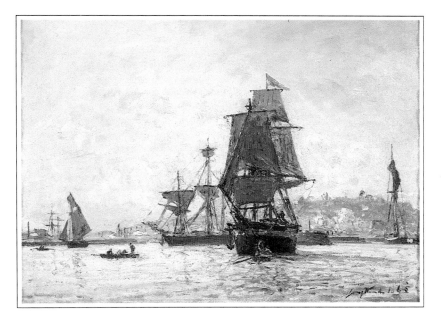

THE CONFIDENT HANDLING of paint and the subtle tone values demonstrated in this painting were two of the characteristics of Jongkind's work most admired by Boudin and Monet. His sensitive feeling for seascapes with freely painted skies, which to us are reminiscent of Constable's sketches, struck a blow against the salon art of his day. Jongkind also had a feeling for broad compositions without fussy detail: in this painting there are no extraneous details to destroy the strong atmosphere of ships putting out to sea, and the broad, rough handling of the paint conveys the idea of ships at work rather than in a romantic world of ocean travel.

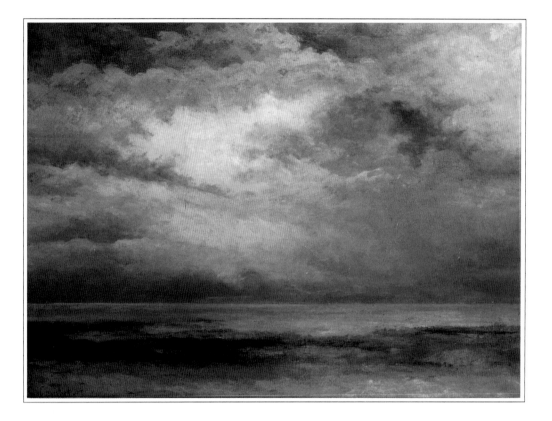

△ **L'Immensité** Gustave Courbet (1819-77)

Oil on canvas

COURBET WAS A ROBUST realist who taught himself to paint by copying Old Masters in the Louvre. When the Louvre bought his painting *After Dinner at Ornans* in 1849 he became an established painter. The strong naturalism of his style, though criticized in Paris, was accepted in less sophisticated cities, though his political views were suspect everywhere. He was anti-Imperialist and anti-Catholic and when the Vendôme Column, erected in Paris to commemorate Napoleon's victories, was knocked down in 1871, he was arrested and eventually handed out a financially crippling fine for his part in the affair. Courbet's interest in the sea was like his interest in nature which he saw as a powerful natural force spelling Freedom.

▽ **Seascape in the Nord-Ouest** 1895
Eugène Boudin (1824-98)

Oil on canvas

BOUDIN WAS BORN in Honfleur, a small picturesque harbour in Normandy and devoted his life to painting scenes in the port or along the shores and coast nearby. His interest in ordinary people enjoying their leisure preceded the Impressionists' and his paintings often show groups of gaily dressed people preparing to board steamers or sitting along an esplanade, enjoying the sea breezes. Boudin did not involve himself in any of the aesthetic theories current during his life, evolving a personal style of painting which is unmistakable. In this painting of a windswept shore, dominated by scudding grey clouds, there is a realism which evokes Courbet and Jongkind.

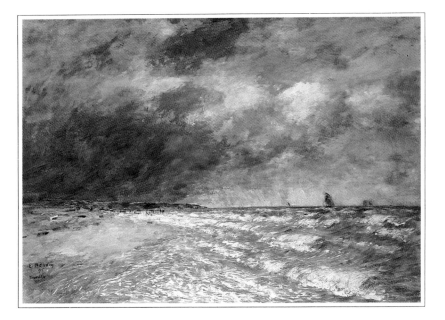

▷ **L'Entrée du Port de Havre**
Eugène Boudin

Oil on canvas

THIS DASHING PAINTING OF a sailing ship entering the port of Le Havre has a verve and confidence that rivals Delacroix, an artist whom the Realist painters admired. The surf and sky give a feeling of air and movement which Boudin had found in the work of his friend Corot and which he passed on to Monet, who later declared that Boudin had opened his eyes to what painting was really about. Though not an Impressionist, Boudin exhibited with the Group in 1874 and was considered one of them. His friendship with Monet continued throughout his life: without his encouragement the Impressionist movement could well have lacked its leading figure, Claude Monet.

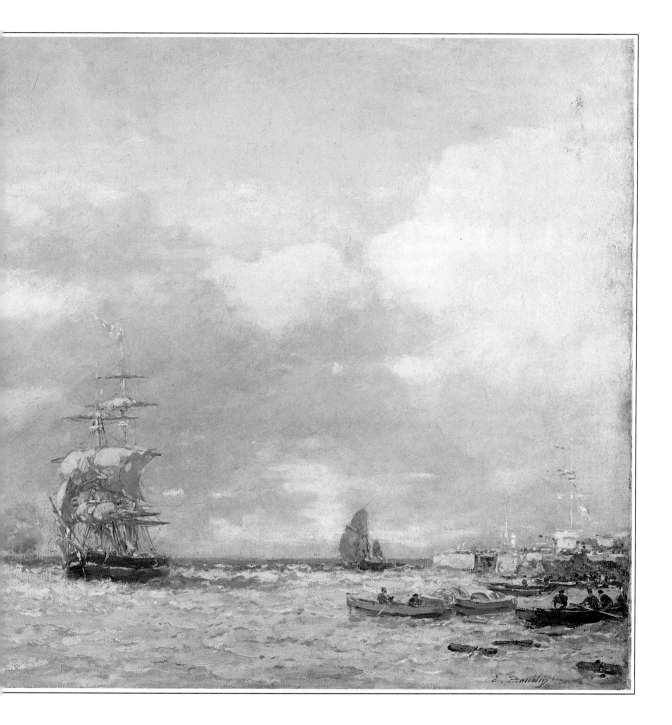

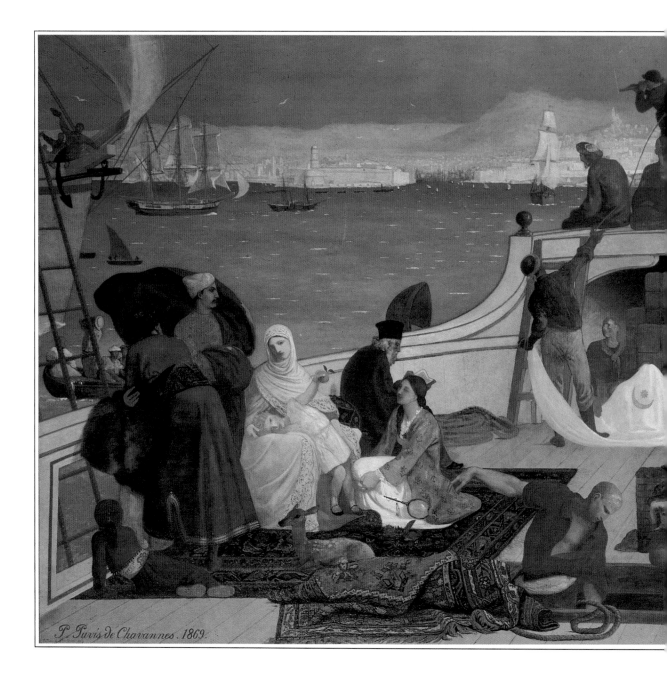

P. Puvis de Chavannes. 1869.

◁ **Marseilles, Gate to the Orient** 1869
Pierre Puvis de Chavannes (1824-98)

Tempera

MARSEILLES, the greatest Mediterranean port for travel to the Far East, was a subject worthy of the talent for murals of Puvis de Chavannes, an artist who painted in traditional style but with the clear composition and flat areas of paint which the Impressionists had learned about from Japanese prints. In this painting Puvis de Chavannes has simplified the busy shipboard scene with its diverse crowd of passengers and crew sailing to the East, and left uncluttered the view of the sea and the port of Marseilles in the distance. Many of de Chavannes' murals and paintings had mythological or symbolic subjects, which have led him to be classed as a Symbolist, along with Gustave Moreau and Odilon Redon.

▷ **On the Thames** 1876
James Joseph Jacques Tissot
(1836-1902)

Oil on canvas

TISSOT WAS A FRENCHMAN who
chose to settle in England
during the Franco-Prussian
war of 1870, London becoming
his base for the rest of his life.
He was much enamoured of
English society, which he often
portrayed with a charming
lightness of touch on ships and
yachts, symbols of success and
world supremacy. He was a
friend of Whistler and knew
Degas and the Goncourts in
France but had little contact
with other avant garde
painters and writers of his day.
Technically, he was a master of
conventional painting, using
his technique to bring a bright,
open-air look to his work. For
this picture of a pleasure craft
moving confidently among the
great ships in what was then
Britain's busiest port, Tissot
clearly made a careful study of
the various kinds of shipping
to be found there. The
indolent young man and two
handsome ladies suggest a
pride in Britain's mastery of
the seas which all his admirers
shared.

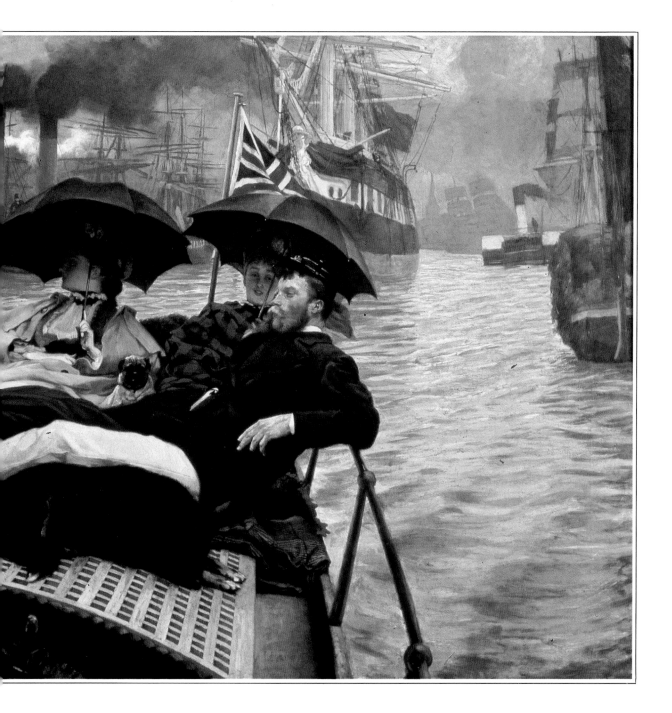

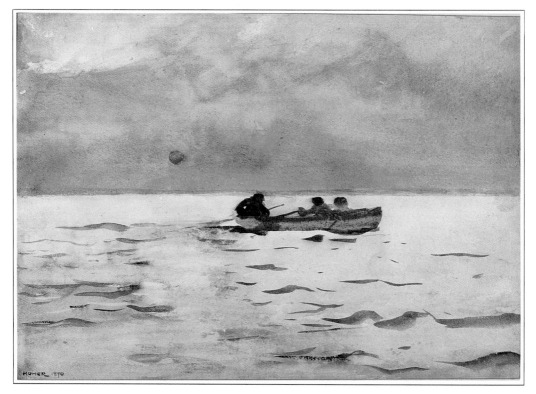

△ **Rowing Home** 1890 Winslow Homer (1836-1910)

Watercolour

THE NEW IDEAS on painting being developed in Paris in the second half of the 19th century only slowly percolated into artistic practice beyond France, though by 1890 some of the Impressionist techniques had become familiar worldwide. The American artist Winslow Homer, who had started life as a lithographer, travelled in France and England in the 1860s, but did not allow himself to be over-influenced by the new theories about painting. He held firmly to the idea that to become a good painter one should not spend too much time looking at other people's work. By the end of the century Homer had become one of America's most influential painters and the country's foremost painter of seascapes, often in a quasi-Impressionist style. He has used a Whistlerian monochrome for this study of a fishing boat making for home, creating an atmosphere which combines realism with mystery.

▽ The Rocks at Vallières, near Royan
Odilon Redon (1840-1916)

Oil on canvas

ODILON REDON had two painting personalities, one that painted imaginary fantasies and another that produced straightforward studies of flowers and landscapes. This study of cliffs near Royan on France's Atlantic coast where the Gironde reaches the sea, is as realistic as anything Courbet might have painted. Redon was a supporter of Post-Impressionism and helped to create the Société des Artistes Independants which succeeded the Salon des Independants when that ceased to exist.

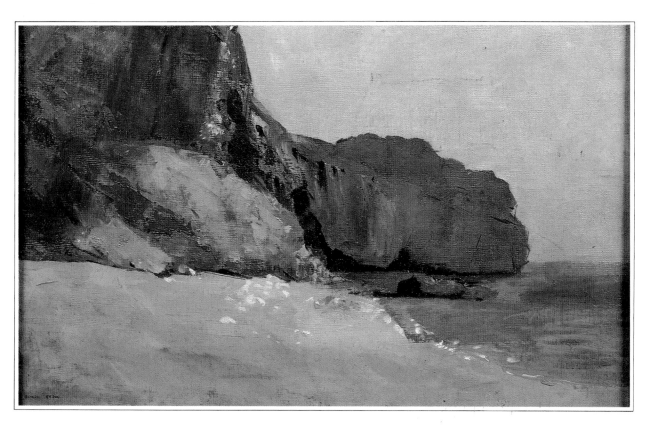

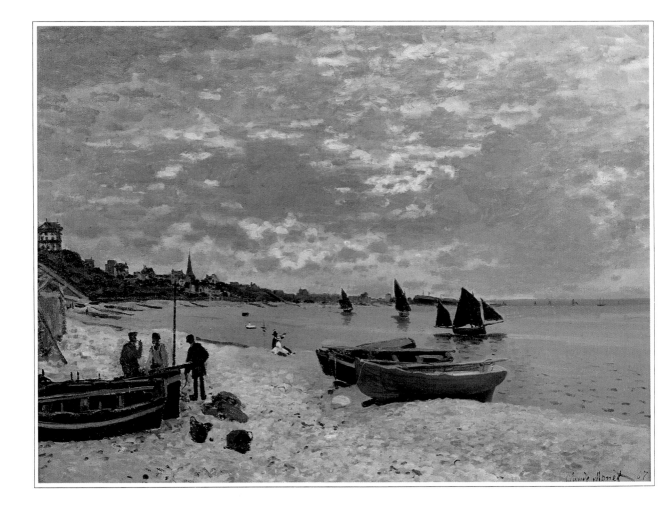

◁ **The Beach at St Adresse**
1868
Claude Monet (1840-1926)

Oil on canvas

BEFORE HE FULLY DEVELOPED his Impressionist style, Claude Monet's work was not unlike that of his friends Boudin and Jongkind, as one can see in this painting of the shore at St Adresse near Le Havre. The colours are muted and applied in a conventional way, except for the beach in the foreground where the short brush stroke of Impressionist technique is evident. Monet's artist friends at Le Havre persuaded him to take up painting as a career and he moved to Paris and then to Argenteuil, where scenes on the River Seine replaced, for a time, those by the sea. It was at Argenteuil that Monet, Renoir, Pissarro, Sisley and others met to discuss their new ideas.

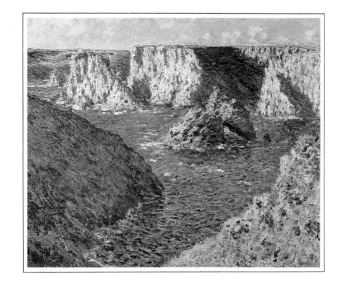

△ **The Rocks of Belle Isle** 1886
Claude Monet (1840-1926)

Oil on canvas

MONET WAS IN LOVE with the sea from the time he was at school in Le Havre and his passion was encouraged by the painter Eugène Boudin who lived there and took the young Monet on expeditions to paint the harbour and shore. Later, Monet would go to places by the sea to paint subjects which appealed to him and to the increasing numbers who bought his paintings. A favourite place was the island of Belle Ile off the coast of Atlantic France. While working here, he produced some fifty paintings of the rocks in many moods, in sun and in storm. In this painting he has given the sea and rocks a liveliness and depth which could hardly have been achieved without the Impressionist technique he had developed of laying on pure colours in short strokes.

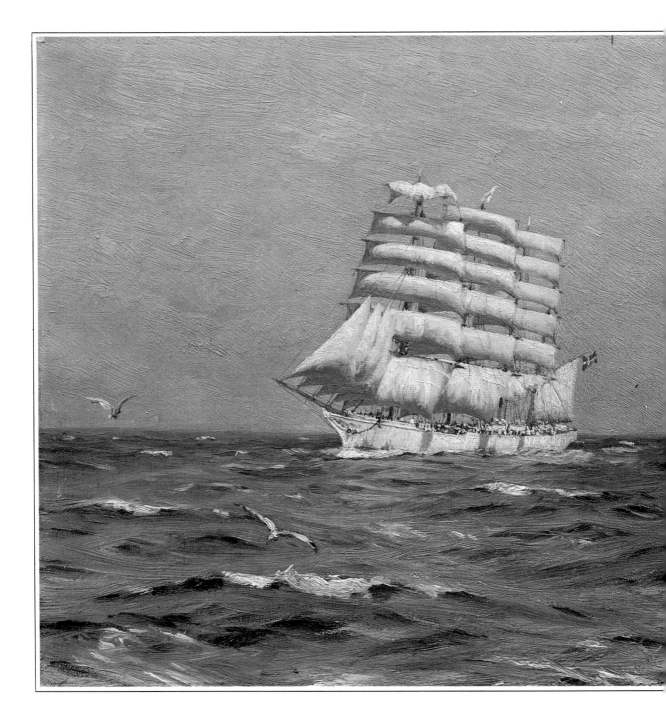

◁ **Danish trading ship,** *Viking* 1910
Thomas Somerscales (1842-1927)

Oil on canvas

PAINTINGS OF SAILING SHIPS on the high seas still quickened the blood of Englishmen when Somerscales painted this romantic picture of a Danish vessel in full sail. Somerscales was himself a traveller and worked for many years in Valparaiso, Chile, the main port on the west coast of South America and the business centre for the mining regions of the north of Chile and agricultural regions of the south. The great ship seen here was the last of the Pacific windjammers which raced around the world laden with goods for sale in American and European markets and Somerscales would have seen many of them in Valpariso Bay during his years as a schoolmaster at the local English school.

▷ **Commerce and Sea Power**
William Lionel Wyllie
(1851-1931)

Oil on canvas

BRITAIN'S MASTERY of the sea
and public awareness of the
great sea voyages undertaken
by British ships gave artists a
subject of immense popular
interest. In this painting
Wyllie, a popular artist who
was a friend of Charles
Dickens and the painter David
Roberts, has combined the
image of great sailing ships
and coastal shipping (on the
left of the picture) with the
fleets, including a battleship
proudly flying the White
Ensign and Union Jack, that
guarded the shipping lanes
(on the right). Sail and steam
were both prevalent among
British shipping until the end
of the 19th century and artists
were reluctant to give up the
romantic image of the former
in their sea paintings.

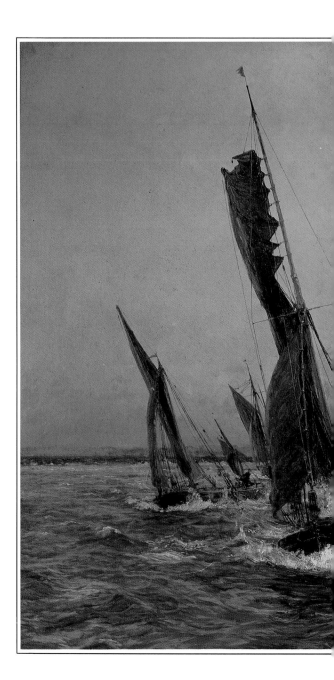

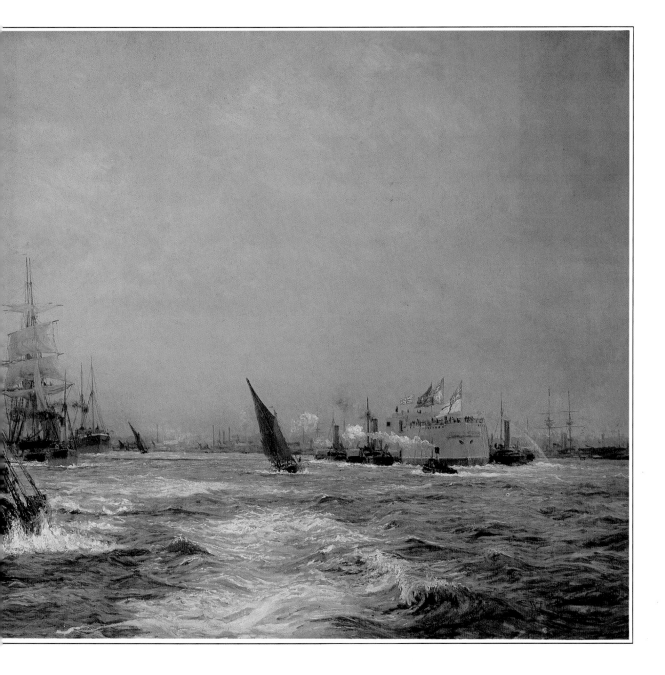

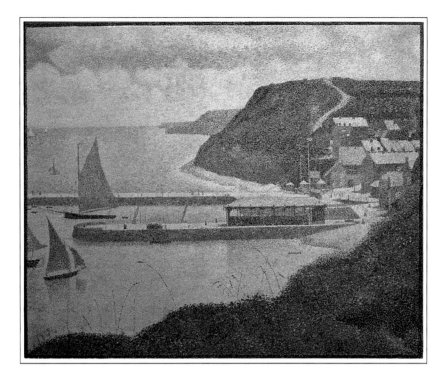

△ **Harbour at Bessin Port** 1886
Georges Seurat (1859-91)

Oil on canvas

THE NEO-IMPRESSIONISTS were a group of artists who created a new rationalised kind of Impressionism which they called Divisionism. Their theory was that small dots of the primary colours that made up other colours would, when put on the canvas, merge in a viewer's eye, creating a livelier effect than if the colours were already mixed on the palette. This technique was allied to a more formal style of drawing and composition than Impressionists used. This almost mechanical brushwork also gave the style the name of Pointillism which Seurat, inventor of the technique, disliked. As the Divisionists often gathered at St Tropez, then a small fishing village, they did many paintings of the harbour and nearby coast. For this painting, Seurat has moved to the north coast of France, where he sometimes painted at Honfleur.

▷ **Harbour, Gravelines** 1890
Georges Seurat (1859-91)

Oil on canvas

THE DIVISIONIST, or Pointillist, technique used by Seurat and his friends echoes the process used by colour photography, which was then in its infancy. Each colour is reproduced by dots of primary colours in different intensities of grouping so that neither one or the other predominates. This mechanical approach to painting initially appealed to many painters, to whom it seemed rational and scientific. Later, they became disenchanted with the rigid system which made everyone's work look alike. In this picture of Gravelines, near Calais, Seurat's colours are colder and greyer than in his paintings in southern France.

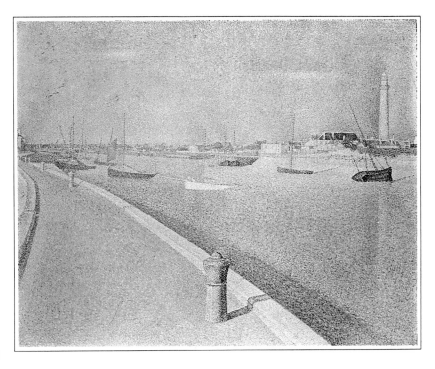

▷ Entrance to the Port of Marseilles
Paul Signac (1863-1935)

Oil on canvas

THIS COLOURFUL PAINTING of a sailing ship being towed into Marseilles by a steam tug echoes Turner's painting *The Fighting Temeraire* in its contrasting of two epochs of shipping. Signac was a loyal follower of Seurat and, like Seurat, had an academic and scientific training which prepared his mind for the idea that art could be rationalised. He wrote a book, *De Delacroix au Neo-Impressionisme* (1899), in which he explained the principles of Divisionism and which found a considerable readership. Like Seurat, Signac was a supporter of the theory of composition known as the Golden Section. This was supposed to provide a ground plan for all successful compositions underlying a painting.

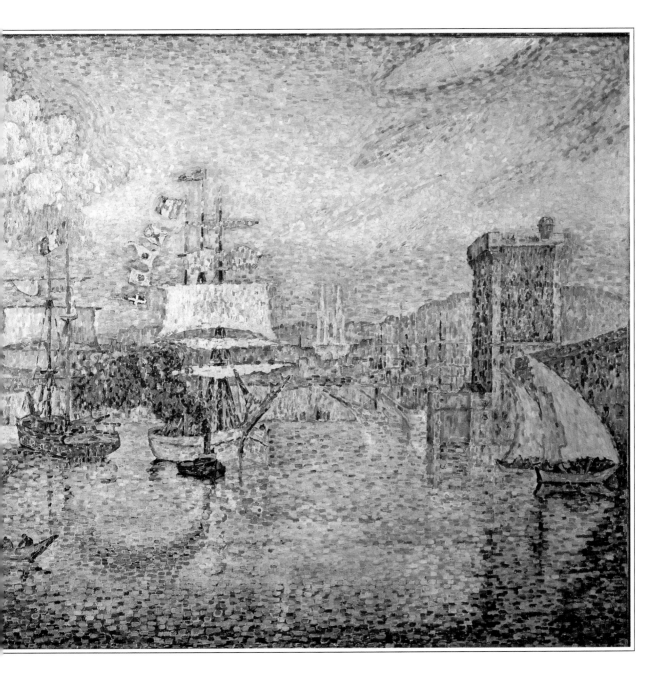

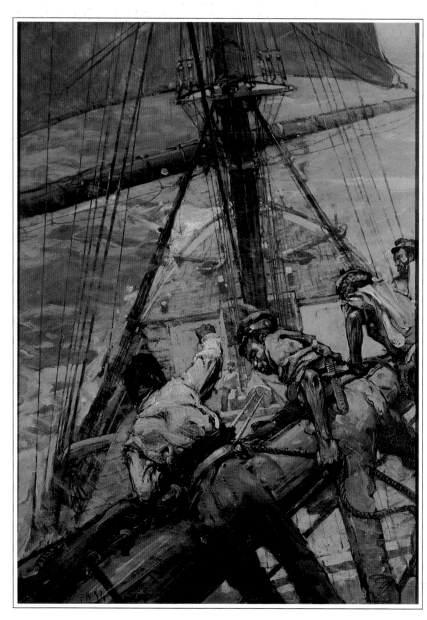

◁ **Heavy Weather in the Channel** c.1914
(Sir) Frank Brangwyn
(1867-1956)

Oil on canvas

THIS SPLENDIDLY evocative
painting of life aloft has the
breadth of treatment that
came naturally to Brangwyn,
who was also a painter of large
murals. The subject was one
which would have appealed
to his generation of young
British men who often spent
a year between school and
university or settling down
to work as crew members on
sailing ships. Brangwyn was
not concerned with the
theories on art that were
driving young painters in
Paris but had a mastery of
drawing which was the forte
of British art of the period.
A Welshman by origin,
Brangwyn was born in
Bruges, where there is a
museum of his work. He was
made an RA in 1919 and was
knighted in 1941.

▷ **Maine Islands** c.1922
John Marin (1870-1953)

Watercolour

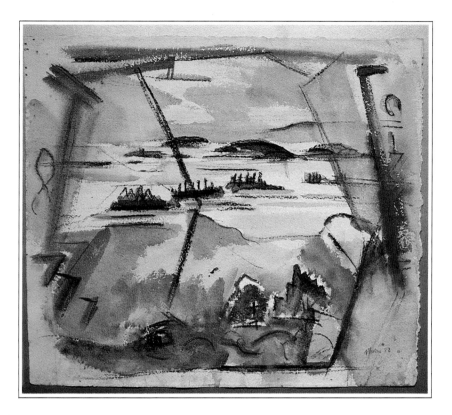

THIS WATERCOLOUR is typical of the work of the American artist, John Marin, both in its semi-abstract treatment and in its subject - the sea. Marin began his artistic life as an architect but after visting Paris, where he fell under the influence of Whistler, he decided to devote himself to painting. A solitary worker, he did not belong to any group but developed his own style which, while bordering on the abstract, never entirely deserted the subject. In this painting of the islands off the coast of Maine, on the east coast of the USA, he has handled the paint loosely but in a strongly structured basic composition in which one senses that a feeling for rational construction is struggling with a romantic vision.

▷ **Landscape at Midday**
Albert Marquet (1875-1947)
© ADAGP, Paris and DACS, London 1995

Oil on canvas

ALTHOUGH HE LIVED and painted at a time when theories about painting and experimental techniques were rife, Marquet was not carried away by any of them, choosing to pursue his own individual style instead. He did borrow those aspects of technique which suited him, however. In this painting of a scene in the south of France, probably L'Estaque, the composition is broadly that of a Japanese print and there is a suggestion of Fauve colouring. Later in his career, Marquet developed a style of painting in fine tones of grey - despite the fact that his greatest friend was the superb colourist Henri Matisse.

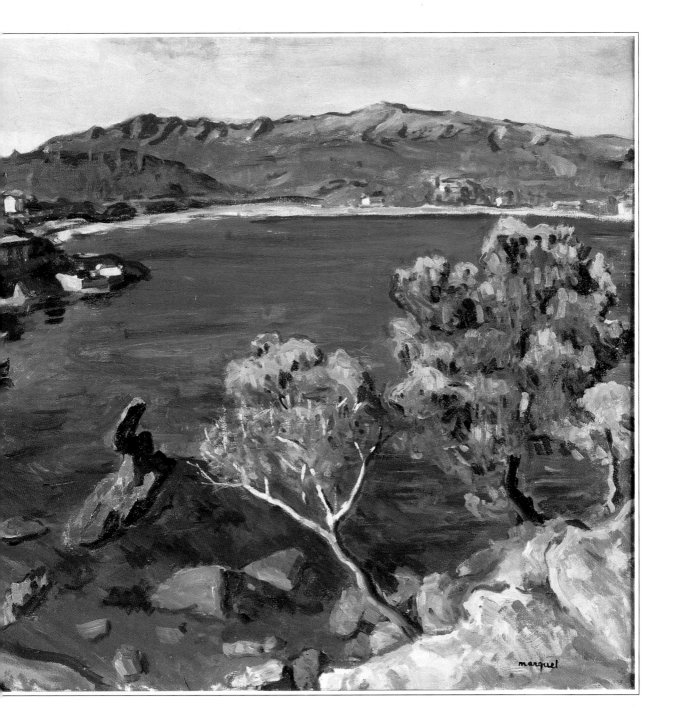

▷ **Barques** c.1905
Maurice de Vlaminck (1876-1958)

Oil on canvas

A RACING CYCLIST turned artist, Vlaminck was a tempestuous painter who broke the rules but produced extraordinarily memorable landscapes which often seem to portray the earth undergoing violent upheavals. His free-wheeling approach to painting came from his Russian spirit which, like those of Chagall and Soutine, was driven by a powerful feeling of independence stronger than the aesthetics of western Europe. With his free and heavy brushstrokes applied with frenzied energy, Vlaminck is easy to mistake for a Fauve. In fact, his real inspiration came from Courbet and van Gogh, both strong and individual personalities. Vlaminck's love of speed, crowds and stormy scenes continued throughout his life.

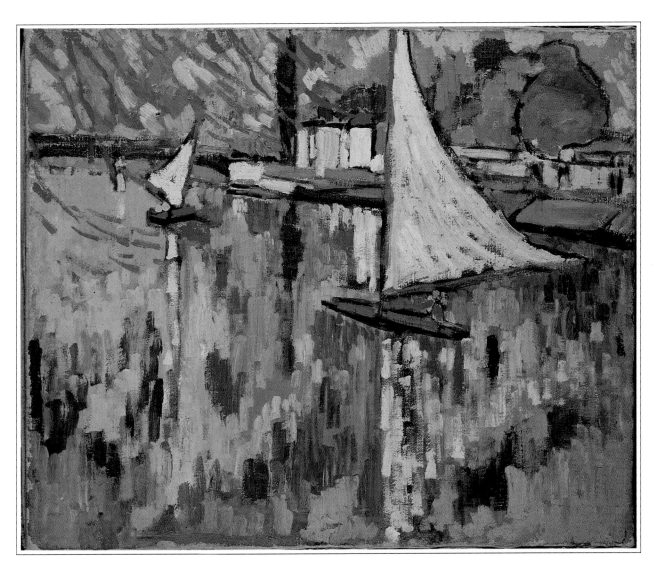

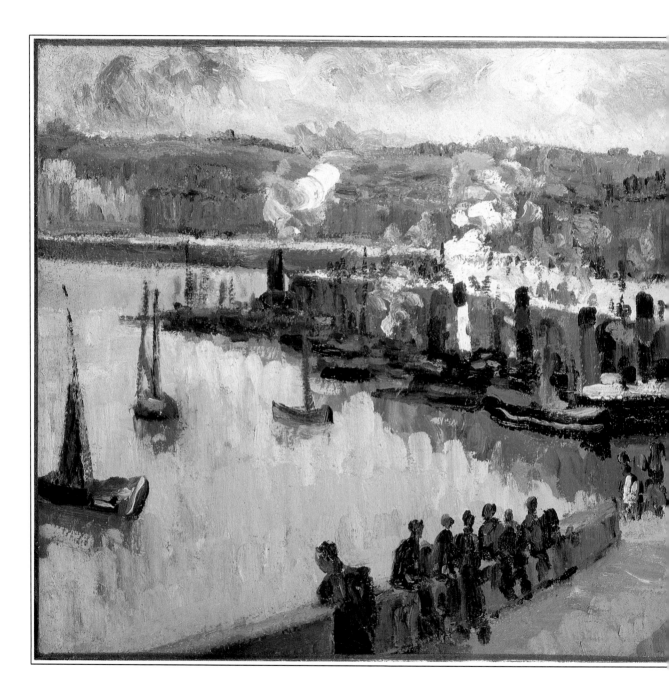

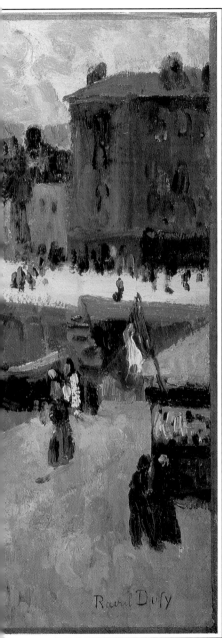

◁ **The Port** c.1906
Raoul Dufy (1877-1953)
© DACS 1995

Oil on paper

DUFY WAS AS SUCCESSFUL a
designer of textiles and
tapestries as he was a painter.
His technique was influenced
by the Fauves, though he
developed his own way of
dealing with colour and
drawing. In this early
painting of a French port
he is still handling paint in
a way reminiscent of the
Impressionists; later, he
gave greater freedom both
to colour and drawing by
using a calligraphic style
for delineating objects which
he drew over patches of
colour applied loosely on the
canvas. His love of a
fashionable ambience took
him to Nice, Deauville and
Ascot where he recorded
the fashionable scene in his
inimitable style.

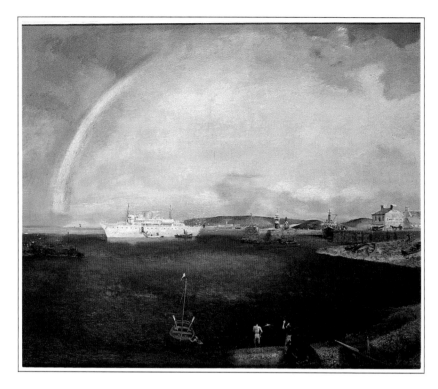

◁ **Rainbow Over the Harbour**
Richard Eurich (b. 1903-92)

Oil on canvas

IN BRITISH-BORN Richard
Eurich's work two historical
aspects of sea painting come
together, for it includes
paintings of sea battles as well
as peaceful scenes. In this
painting a white cruise ship
under a rainbow suggests that
the sea is a leisure playground
on which sea travellers can
make voyages to exotic and
peaceful locations. In Eurich's
work of the war years, on the
other hand, there are
paintings of sinking battleships
and shipwrecked seamen
reminiscent of early pictures of
sea battles from the time when
the English, Dutch and French
fleets were fighting for
maritime supremacy.

ACKNOWLEDGEMENTS

The Publisher would like to thank the following for their kind permission to reproduce the paintings in this book:

Bridgeman Art Library, London /Musees Royaux des Beaux-Arts de Belgique, Brussels: 8-9; /**Private Collection**: 10-11, 42-43, 58, 62-63; /**Alan Jacobs Gallery, London**: 12-13; /**National Gallery, London**: 14-15, 26-27; /**National Maritime Museum, London**: 16, 18-21, 70; /**Christie's, London**: 17, 22-24, 32, 38-39, 52-53, 75; /**Staatliche Gemalde-Galerie, Berlin**: 25; /**Kenwood House, London**: 28; /**Tate Gallery, London**: 28-29; /**Victoria & Albert Museum, London**: 30-31, 40, 50; /**Lincolnshire County Council, Usher Gallery, Lincoln**: 33; /**Haworth Art Gallery, Accrington, Lancs.**: 34; /**Louvre, Paris/Giraudon**: 35; /**Wolverhampton Art Gallery, Staffs.**: 36-37; /**Grace Darling Museum, Edinburgh**: 41; /**Bury Art Gallery & Museum, Lancs.**: 44-45; /**Ackermann & Johnson Ltd., London**: Cover, Half-title, 46; /**Agnew & Sons, London**: 47-49; /**Connaught Brown, London**: 51; /**Musee des Beaux-Arts, Marseilles**: 54-55; /**Wakefield Museums and Galleries**: 56-57; /**Musee d'Orsay, Paris/Giraudon**: 59, 66; /**Art Institute of Chicago**: 60; /**Musee St Denis, Reims**: 61; /**Guildhall Art Gallery, Corporation of London**: 64-65; /**Herron Art Institute, Indianapolis**: 67; /**Musee Cantini, Marseilles/Giraudon**: 68-69; /**Phillips Collection, Washington D.C.**: 71; /**Musee des Beaux-Arts, Le Havre**: 72-73; /**Noortman (London) Ltd**: 76-77; /**Waterman Fine Art Ltd**: 78